SKETCHING **OUTDOORS**

LEONARD RICHMOND

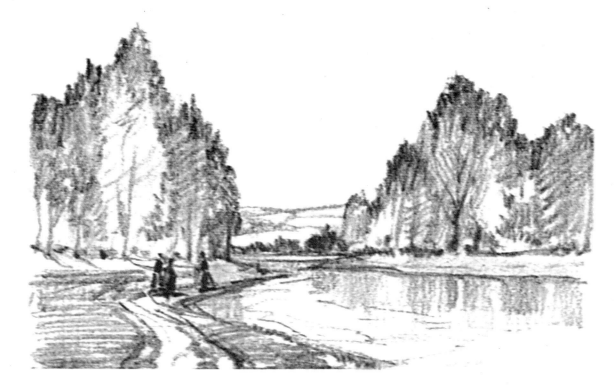

DOVER PUBLICATIONS, INC., MINEOLA, NEW YORK

Bibliographical Note

This Dover edition, first published in 2008, is an unabridged republication of the work originally published by Pitman Publishing Corporation, New York, in 1954.

Library of Congress Cataloging-in-Publication Data

Richmond, Leonard.
 [Sketching out of doors]
 Sketching outdoors / Leonard Richmond.
 p. cm.
 Originally published under title: Sketching out of doors: New York : Pitman
Pub. Corp, 1954.
 ISBN-13: 978-0-486-46922-5
 ISBN-10: 0-486-46922-0
 1. Drawing—Technique. I. Title.

NC730 .R5 2008
741.2—dc22

 2008028439

Manufactured in the United States of America
Dover Publications, Inc., 31 East 2nd Street, Mineola, N.Y. 11501

INTRODUCTION

Drawing with a pencil is a delightful pastime. It is a most expressive medium in the hands of an artist. Armed with a drawing book, pencils, eraser, pencil sharpener or pen-knife, you then have all that is necessary for portraying any subject that may appeal to you. There are countless items in life and nature, awaiting *your* interpretation.

Get the best materials for drawing. Good white—or nearly white—drawing paper. Three pencils: 2B, 4B, and 6B. With a 2B pencil your subject can be outlined before shading, and a 4B pencil helps to suggest clearly defined shadows. The 6B pencil is capable of giving a lovely rich quality to deep toned shadows. The eraser should be soft, but firm. Keep it as clean as possible. To do so, use your eraser occasionally on an odd piece of paper when making a pencil sketch.

Always be ready for any emergency. A good subject sometimes appears in the most unlikely place. You may find it in a station while waiting for a train, or when you are conversing with friends in the living room. Then again, when you are driving through the countryside, a sudden view presents itself so that you feel impelled to stop to make a pencil study of it. An observant artist invariably finds something worth recording no matter whether it is in the big city, in the country, or along the sea coast. Life and nature exist everywhere.

If you are a beginner in this fascinating medium, do not worry unduly at first about getting correct proportions in the subject you wish to draw. Experience will help you as time goes by, so that the eye is eventually trained to observe and correctly space the various items in a picture.

Avoid holding the pencil with a tight grip. To gain freedom and fluency in your drawing, hold the pencil lightly. The beginner should draw main lines and curves only. The basic pattern of a subject is more important than fussy detail.

Pencil drawings are a valuable asset for a painter in oil or water color. For example, an artist may paint a vivid, interesting sketch in which he has successfully caught the drama and force of the subject together with the correct color and tone values. But, in the excitement and thrill experienced during the painting, constructive draftsmanship is lacking. It is, therefore, important for a painter to make several pencil studies so that he may be able to remedy any defects visible in a color sketch.

Apart from the use of a pencil as a help to painters, it should be remembered that a good pencil drawing of high caliber ranks as a work of art equal to the best painting. The medium an artist uses is not in itself as important as the expression of personality, i.e. yourself.

The large number of pencil studies in this book were selected to help *you*. For that purpose, there are many demonstrations enabling you to follow, step by step, the building up of a picture until the final stage is completed.

Make drawings of the simpler studies in this book and memorize them. Then draw some of the more complicated pictures. You will find your efforts most interesting and rewarding, and the information gained will help a lot when you draw direct from life or nature.

Success to your efforts!

Draw parallel lines.

Parallel lines with gradated shading.

Draw parallel lines and then close up the empty spaces between each line.

The above was drawn with a 6B pencil with a flat edge.

Undulating curves seen in ploughed fields.

Cross-hatching is sometimes useful in landscape drawing, but lacks luminosity.

Practice freedom of handling. Hold the pencil lightly.

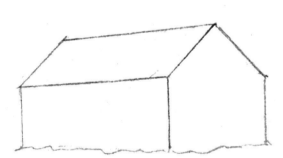

The rigid outline of the above building has no artistic appeal.

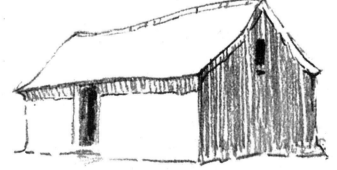

Notice the difference in this drawing, particularly the contours of the roof.

Various Pencil Techniques

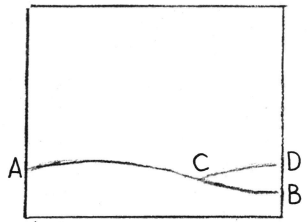

It is most interesting to create one's own pictures. Draw two simple curves A.B and C.D.

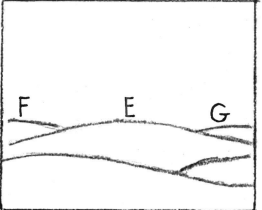

Next, sketch curve E followed by two smaller curves F and G. Study nature and notice how well she balances everything.

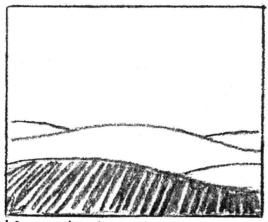

After shading the foreground, you will discover many possibilities for original compositions.

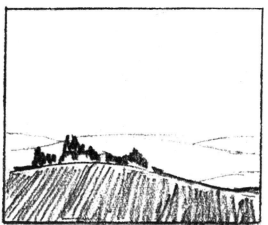

Break the foreground material with suggestive trees and small buildings.

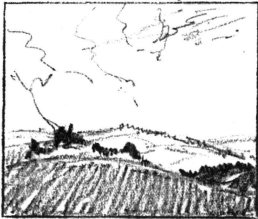

Indicate the positions of dramatic clouds. Add detail to middle distance.

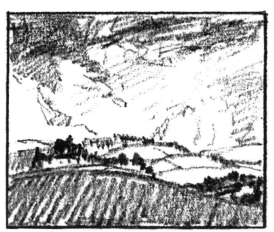

Darken the clouds, keeping the light portion of the sky free from detail.

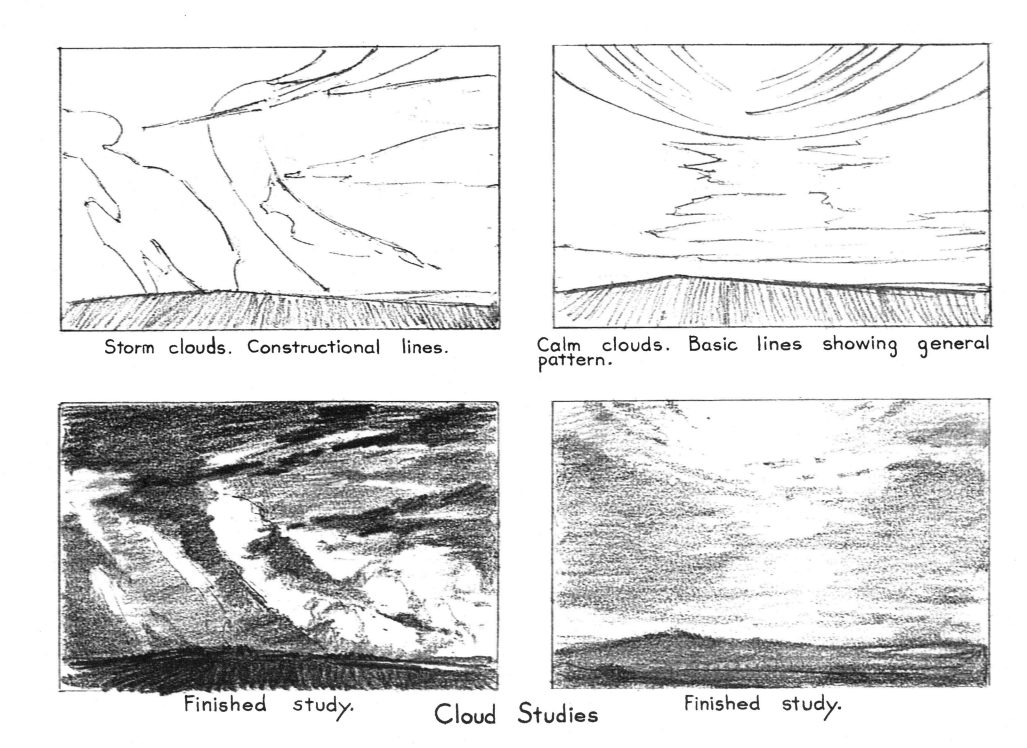

Storm clouds. Constructional lines.

Calm clouds. Basic lines showing general pattern.

Finished study.

Cloud Studies

Finished study.

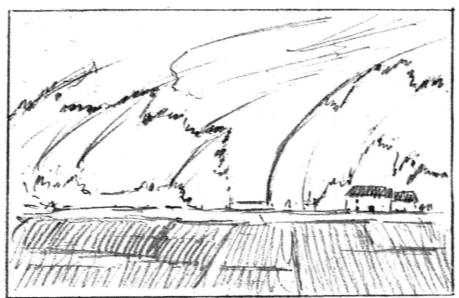

Compositional lines for stormy weather.

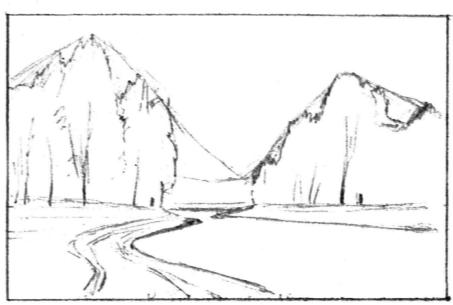

Compositional lines for a tranquil day.

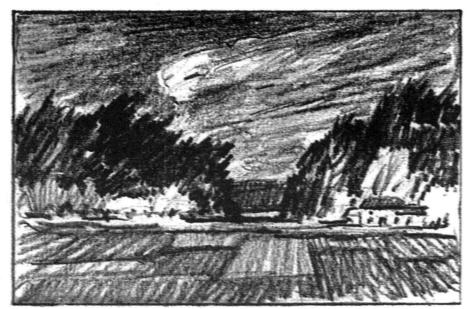

Stormy weather — Finished study.

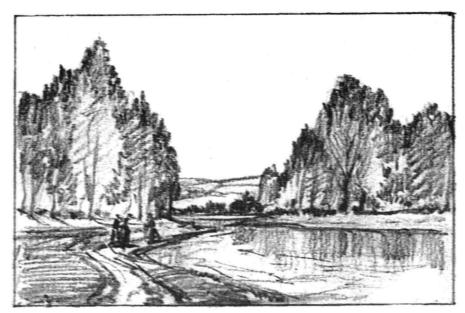

A tranquil day — Finished study.

First stage:
Draw the
general
outline.

Lines
indicating
basic
pattern.

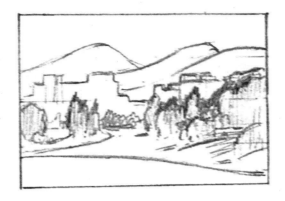

Second Stage:
Shade the
sky, the
distant hills,
and the sha-
dows on the
left side of
buildings.

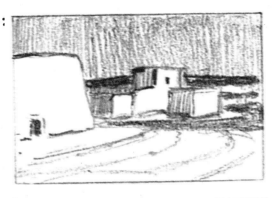

Shade the
distant hills
and empha-
size the
contours of
trees.

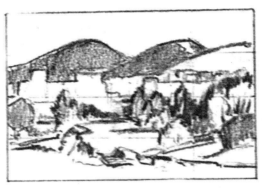

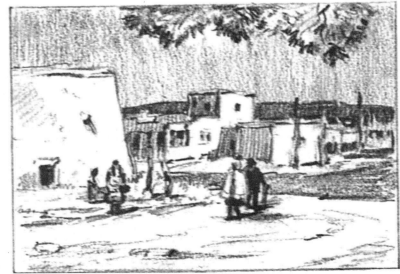

Final study: Draw foliage, posts and figures.

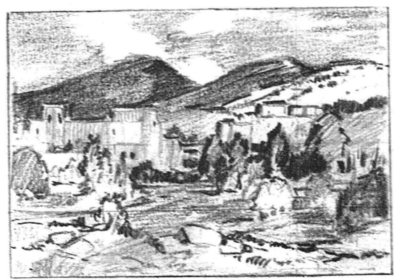

Final study: Draw clouds, buildings and trees.

The area space A.B of the foreground is most important since it supports the weight of various items above.

The position of the trees (see demonstration above) requires thoughtful planning before suggesting detail.

This skeleton diagram explains the basic construction of the tree seen in the central part of the road.

This dark pencil drawing emphasizes the basic construction of the tree without losing naturalistic expression.

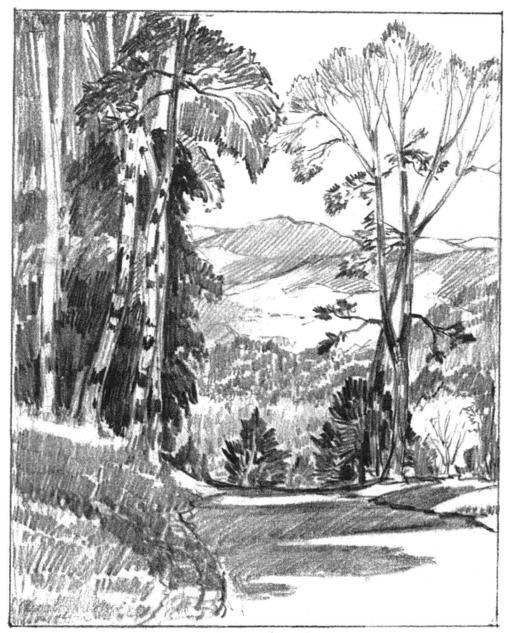

The Approach to Elizabethtown, New York

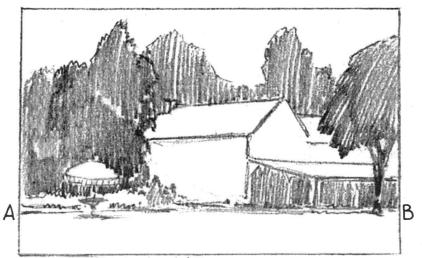

The central building occupies a prominent place in the general composition. The surrounding framework of trees helps to emphasize its pictorial importance.

The low horizon marked A.B adds to the height of trees and building above.

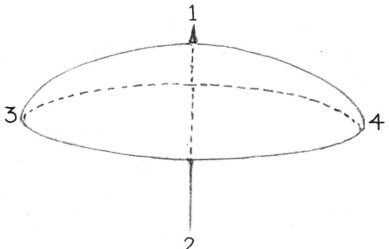

To get correct drawing of a sun umbrella, commence with a vertical line marked 1 and 2. Then draw the elliptical shape 3 and 4.

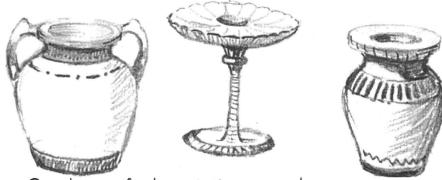

Studies of decorative garden ornaments.

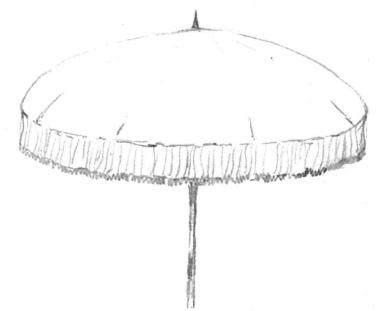

Here is the finished study.

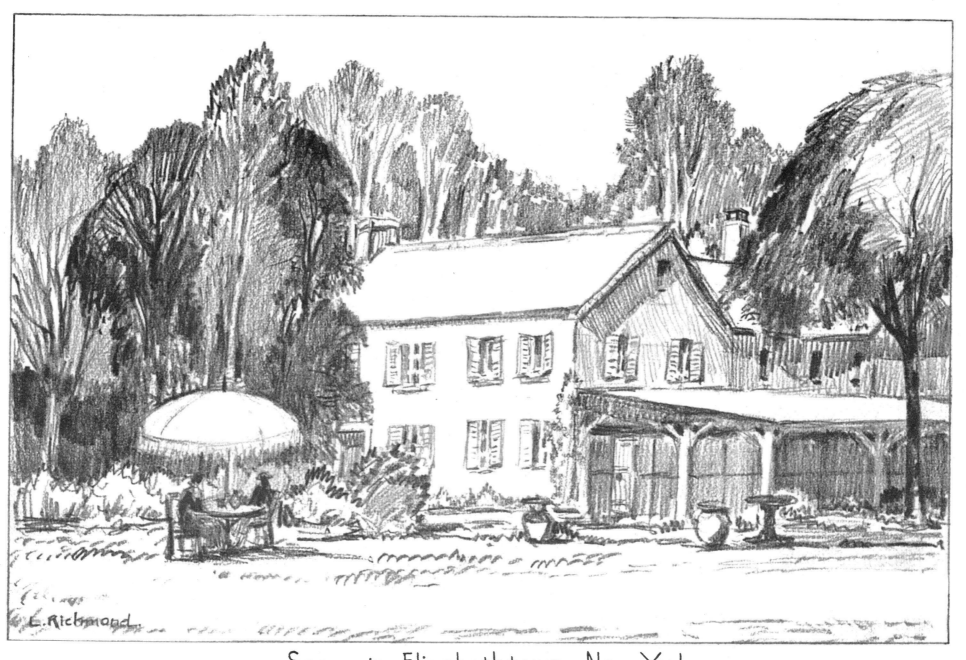

Scene in Elizabethtown, New York

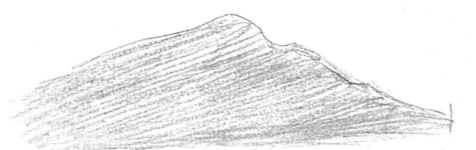

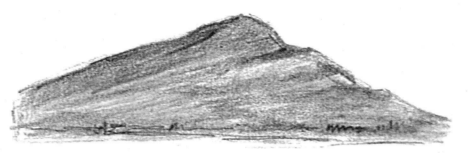

After drawing the contours of a mountain, your best method is to shade an over-all flat tone as above.

Next break the flat tone by suggesting structural formation with appropriate detail, but keep your drawing simple.

Remember that a lot of detail is liable to destroy the dignity of the subject.

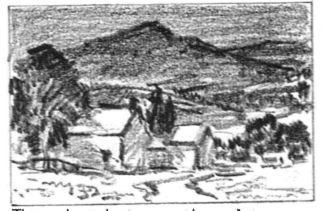

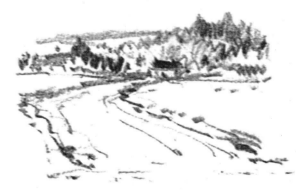

The sun is on the left side, therefore the shadows spread towards the right.

This sketch is another interpretation of the full size picture on the opposite page. Try several ideas for yourself based on the same subject. You will find it a fascinating pastime and conducive to creative thoughts.

A winding road leads the eye into the picture, an important fact sometimes forgotten.

Studies for Cottages near Elizabethtown, New York

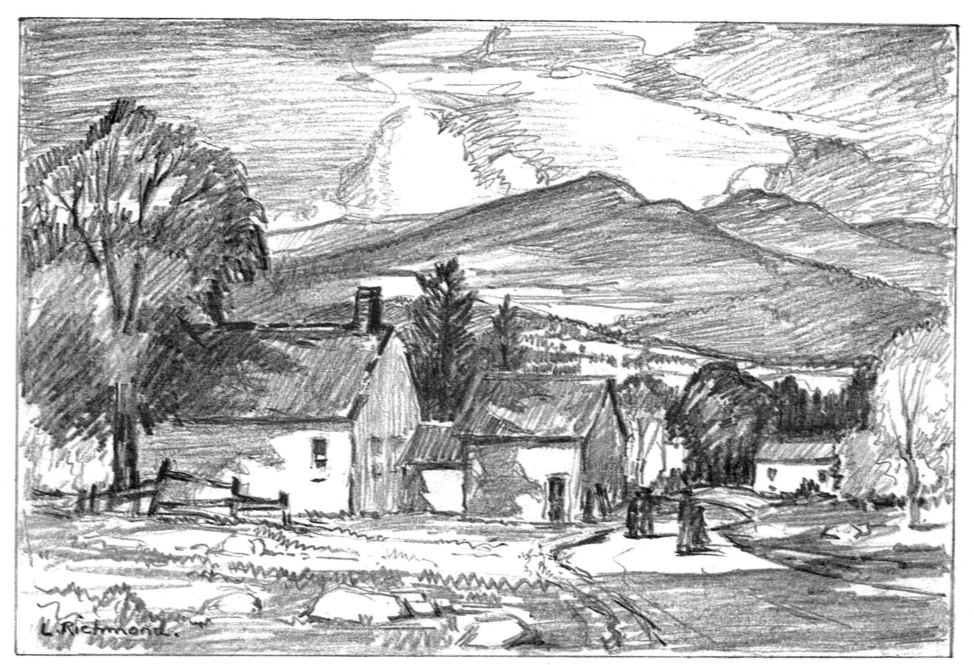

Cottages near Elizabethtown, New York

Find the position of A in relation to B and C. A is the meeting point of converging lines.

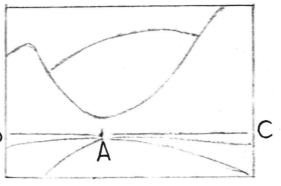

These lines show the position and direction of the general composition.

Now draw with vertical lines the tone of sky, water, and trees.

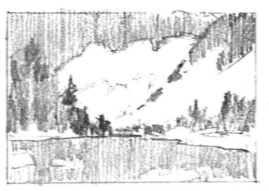

The leading lines above give one confidence for drawing the second stage.

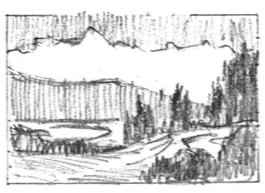

Finally add detail as depicted below.

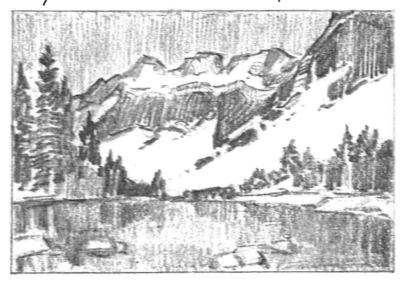

Dark trees make a dramatic contrast.

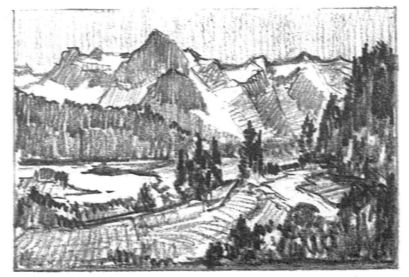

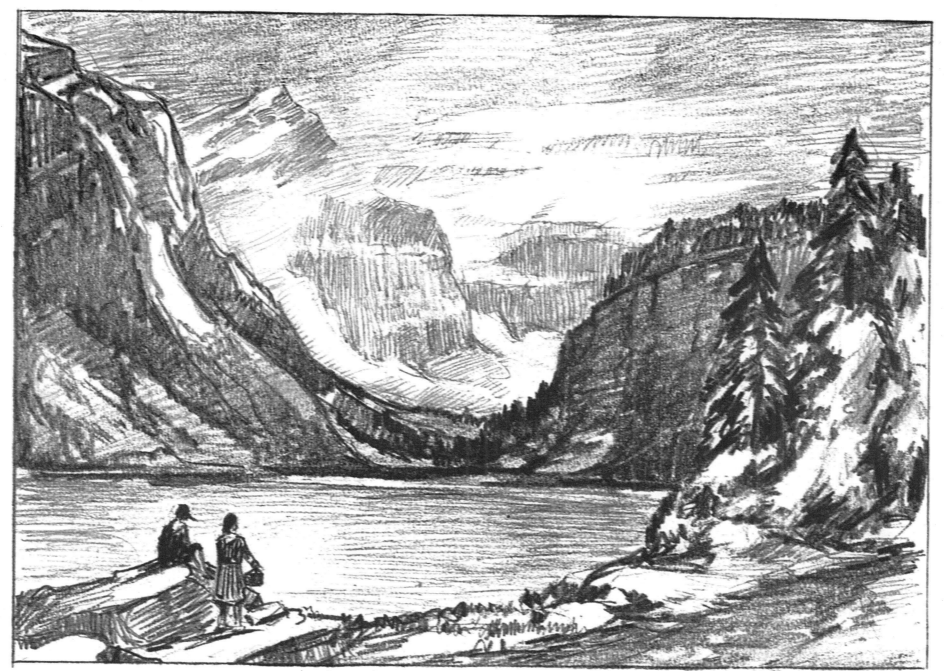

Lake Louise, Canadian Rockies

A

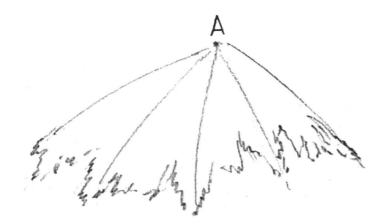

Overhanging foliage on the banks of the river requires constructional drawing. A is the focal point of directional lines.

B

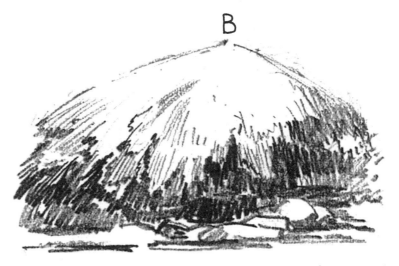

B is a demonstration of naturalistic detail based on the framework of A.

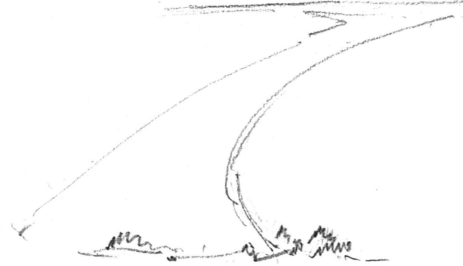

A sweeping curve across the river allocates the position of various pebbles and small rocks.

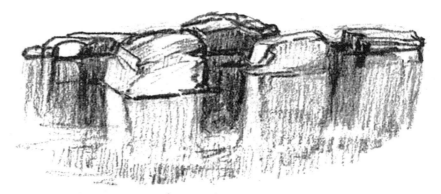

The reflection of rocks on water is most effective when drawn with vertical lines.

Studies for River Bouquet, Elizabethtown, New York

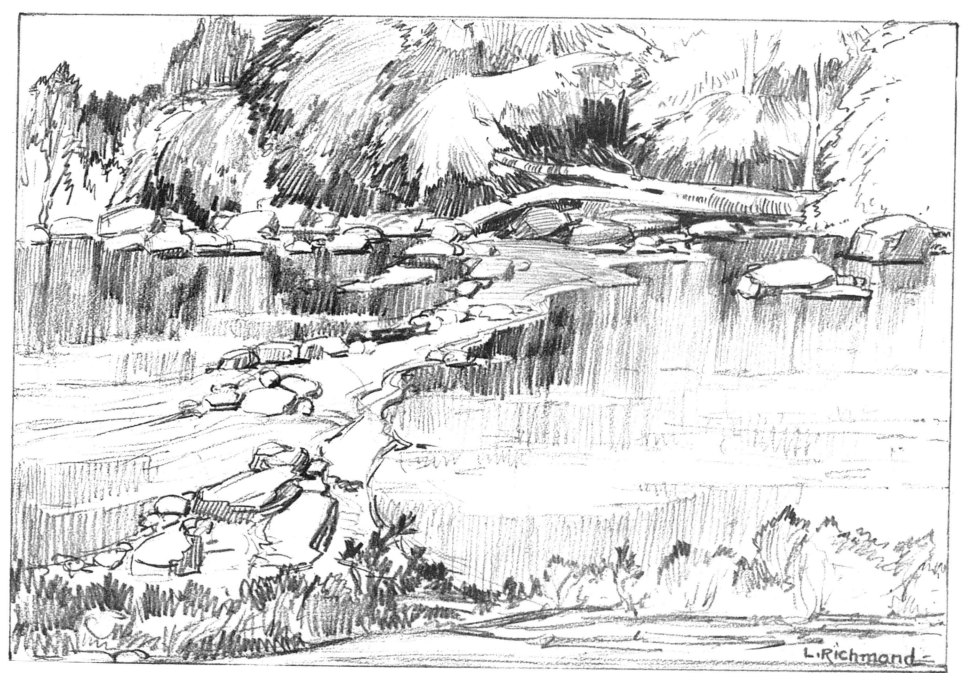

The River Bouquet, Elizabethtown, New York

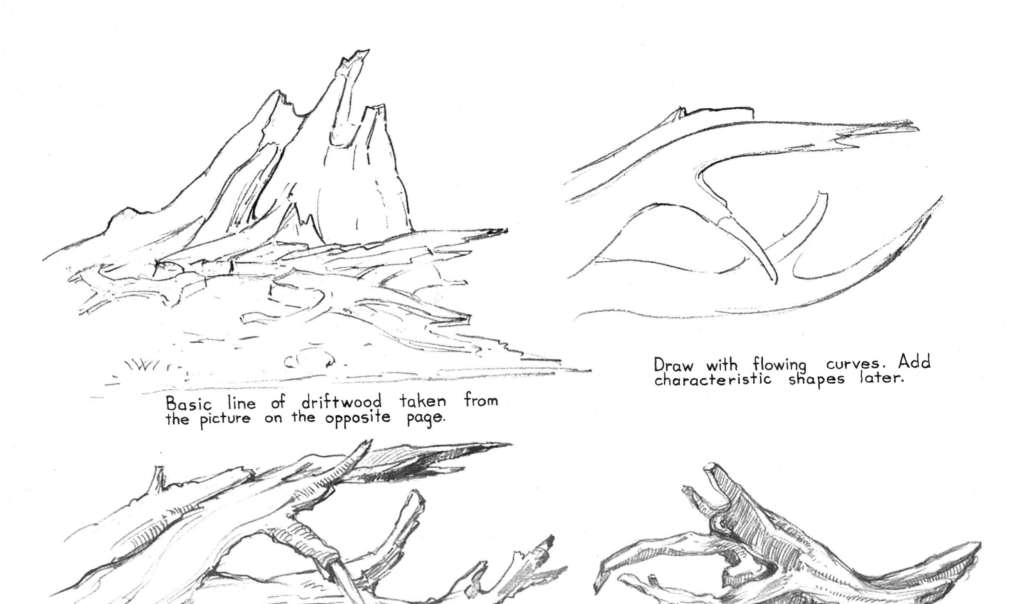

Basic line of driftwood taken from
the picture on the opposite page.

Draw with flowing curves. Add
characteristic shapes later.

Outdoor Studies of Driftwood from Lincoln Pond, New York

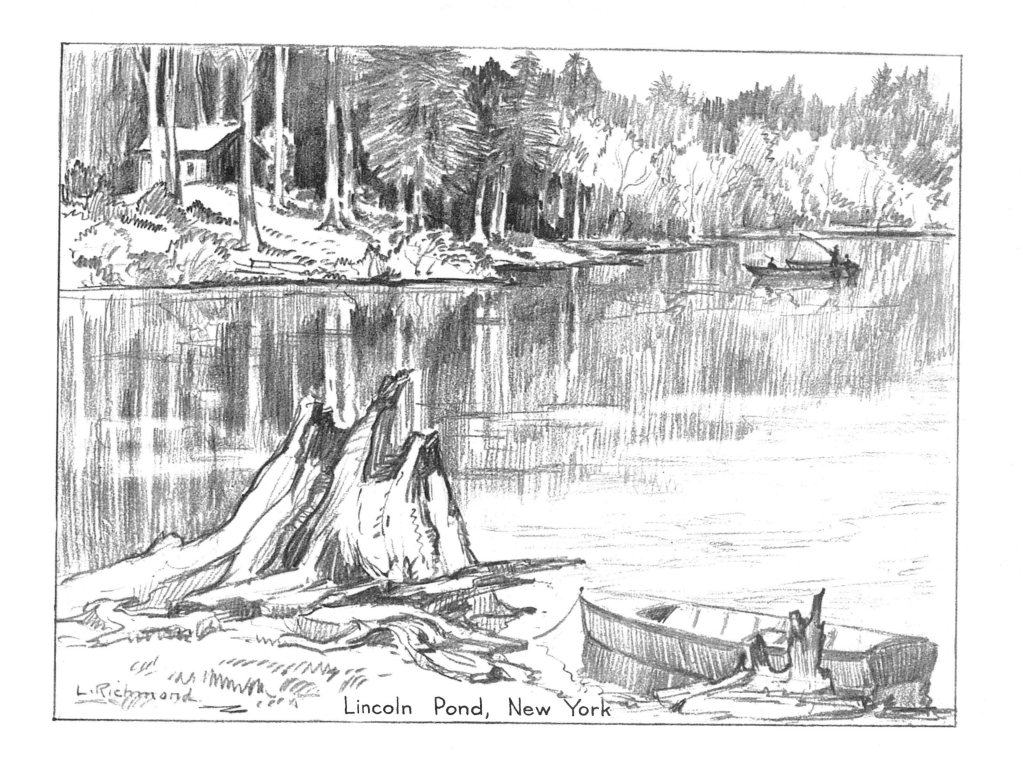

L. Richmond

Lincoln Pond, New York

1

3

2

No.1. This is a demonstration of tapering branches showing how the lower end of each branch becomes less thick and more delicate in contour.

No.2. An example of foliage radiating centrally from each twig. This treatment is essential for those who wish to draw with conviction.

No.3. This was drawn with the flat edge of a 6B pencil so as to indicate the darker edges of foliage. Practice the above three drawings — it is not difficult — and then memorize. Later other types of foliage can be drawn with good technique.

Before commencing the out-door subject, I visualized the general pattern as seen in this sketch. De- tailed drawing followed later. The foreground trees completed the final pattern.

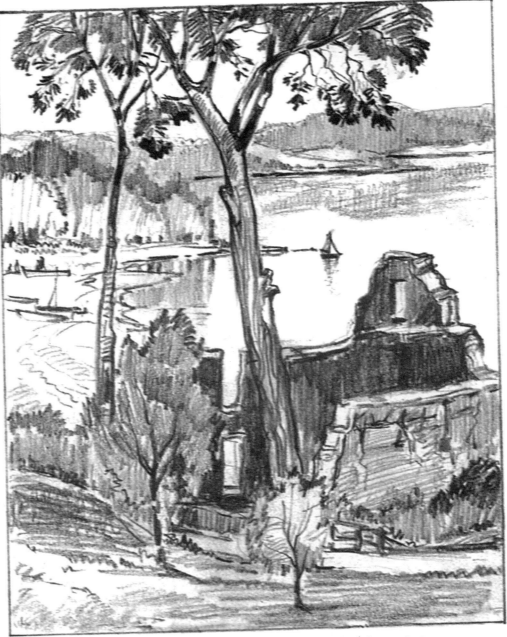

Lake Champlain, Westport, New York

Basic pattern of archi-
tectural rocks.

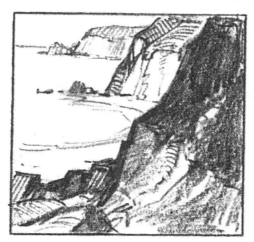

A glimpse of the Pacific
Ocean.

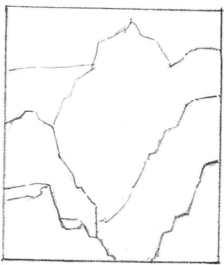

Basic pattern of Rocky
Mountains.

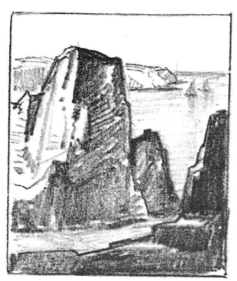

Finished study of archi-
tectural rocks.

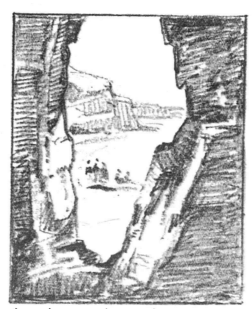

Looking through a cave.

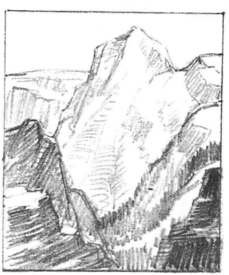

Finished study of Rocky
Mountains.

Pictorial Compositions

Draw this simple example.

Then add A.

Now add B and C.

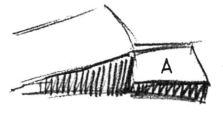

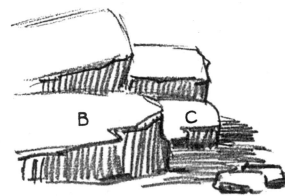

Draw your own rock formation.
Draw easily. Let your pencil
do it for you.

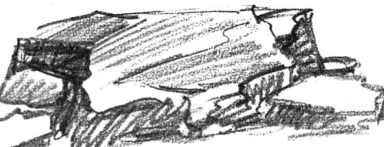

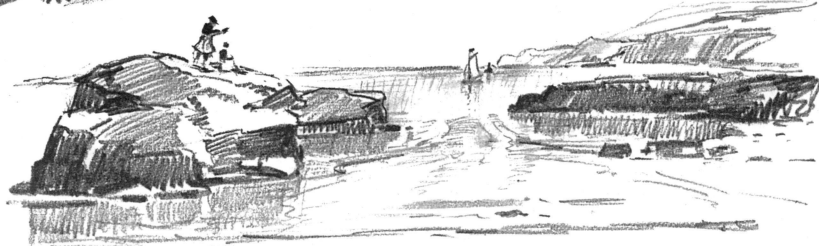

Study of Rocks on the Seashore

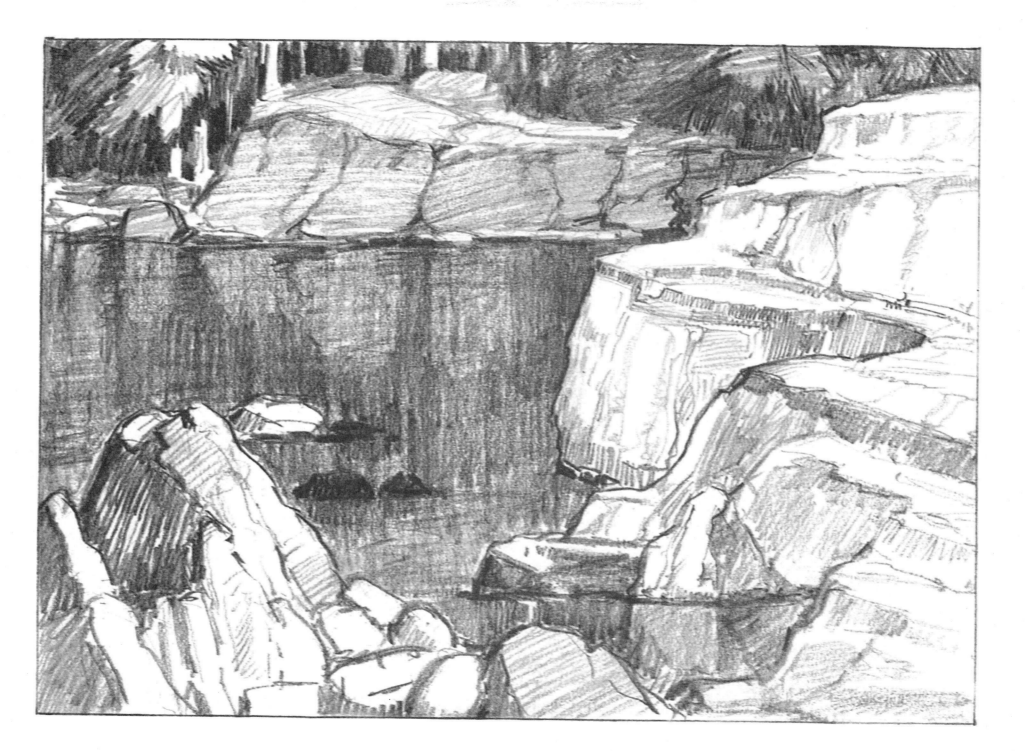

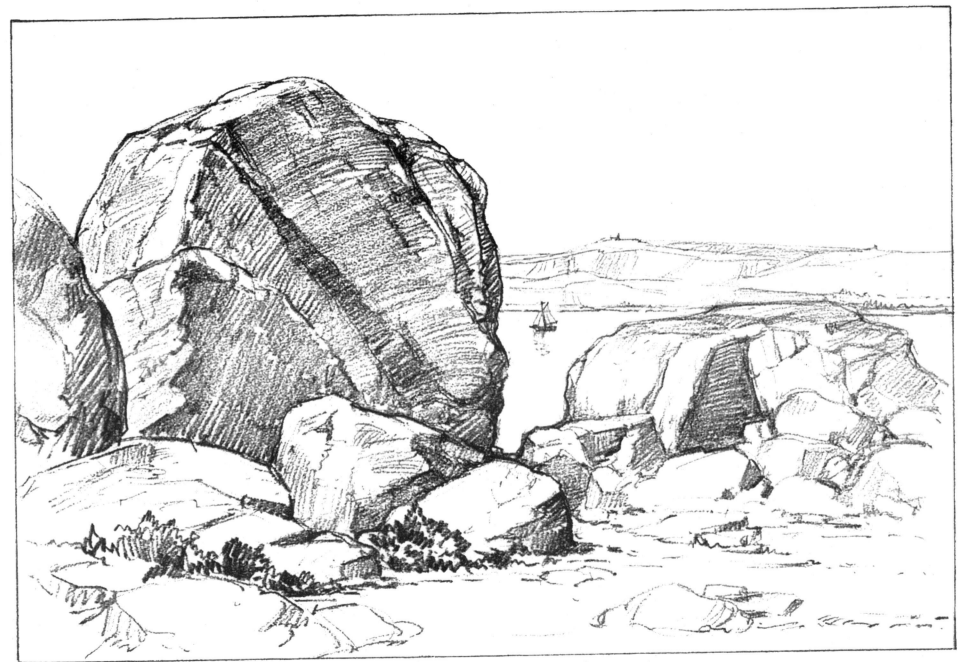

Light Rocks, near Rockport, Massachusetts.

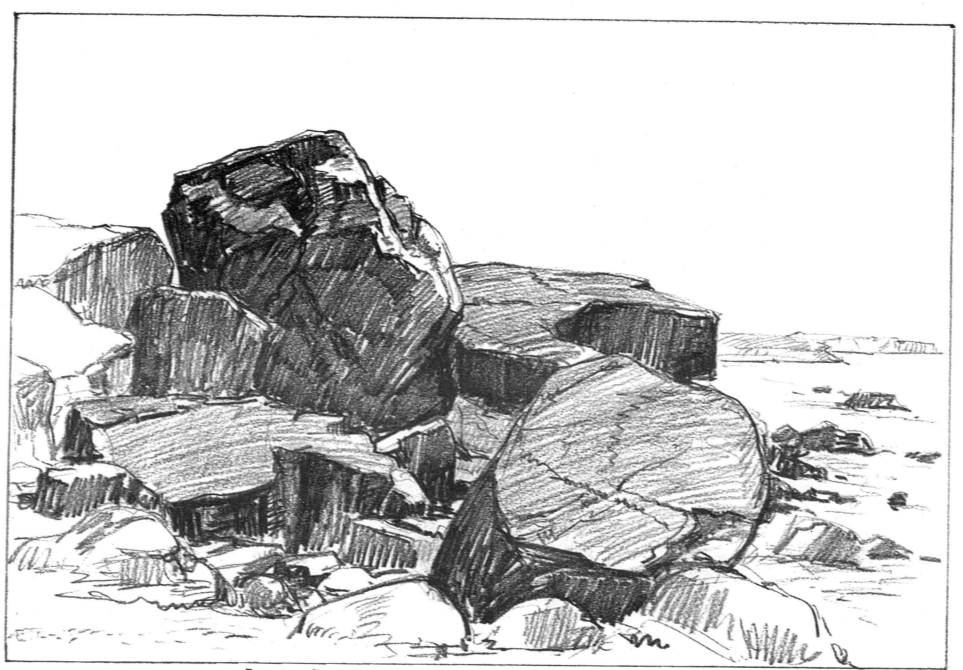

Dark Rocks, near Rockport, Massachusetts

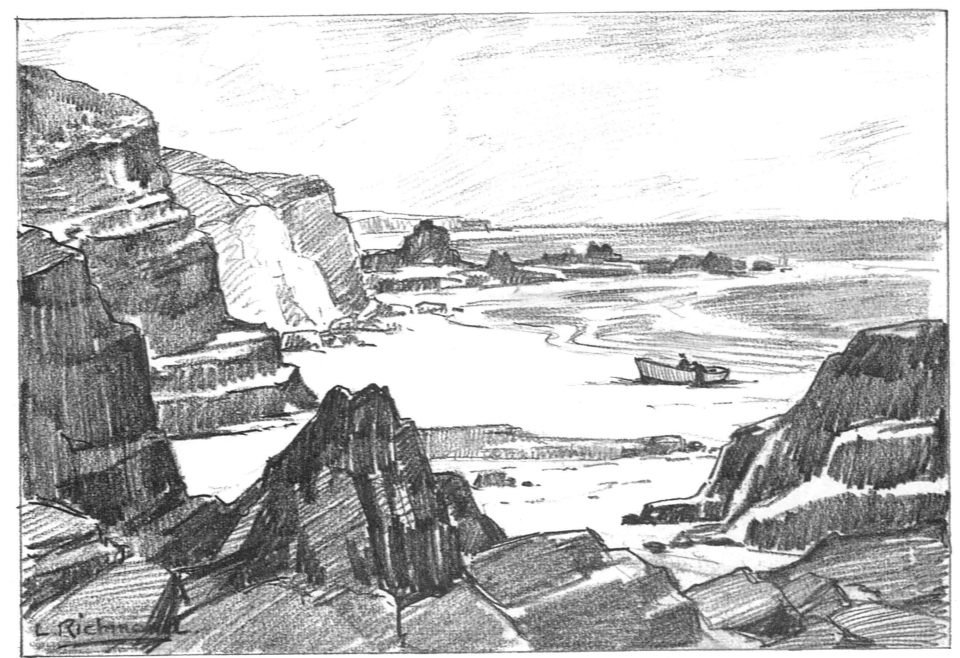

The Cornish Coast, England

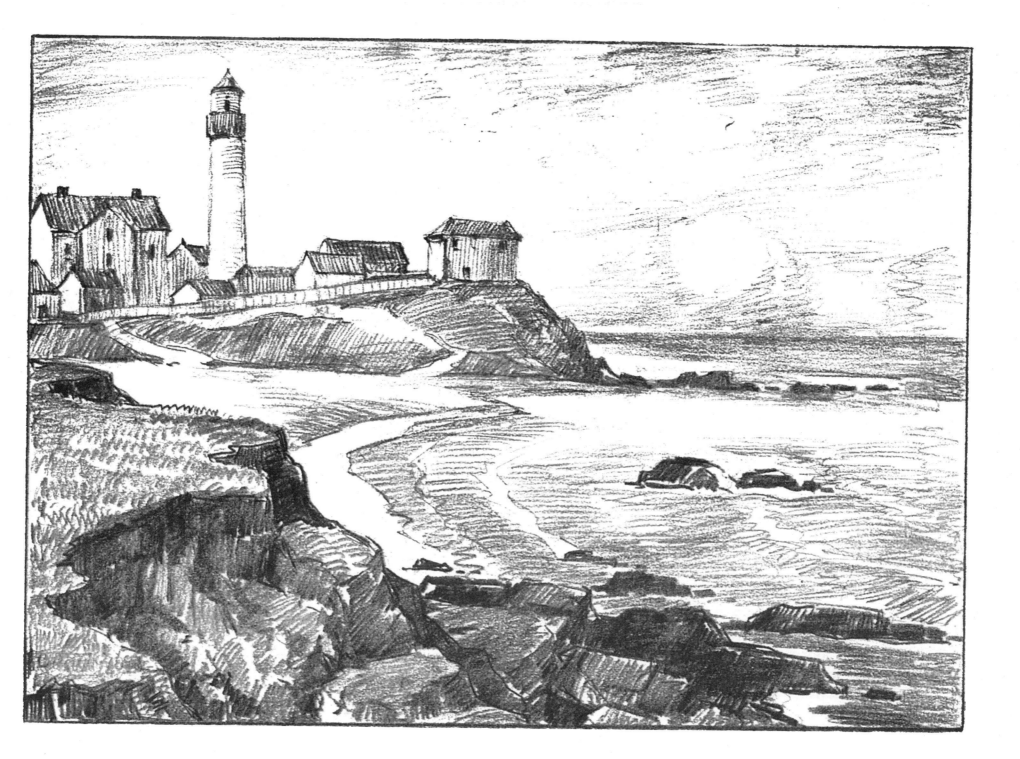

To sketch cows, commence with a simple outline so as to get their characteristic. shapes.

Study of cows resting.

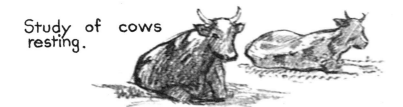

Group of cows and a calf.
This study commenced with simple outlines similar to the top example, followed with shading to indicate structure and texture.

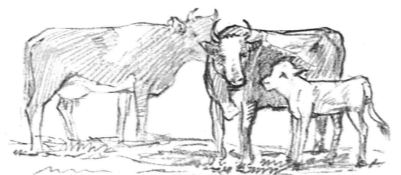

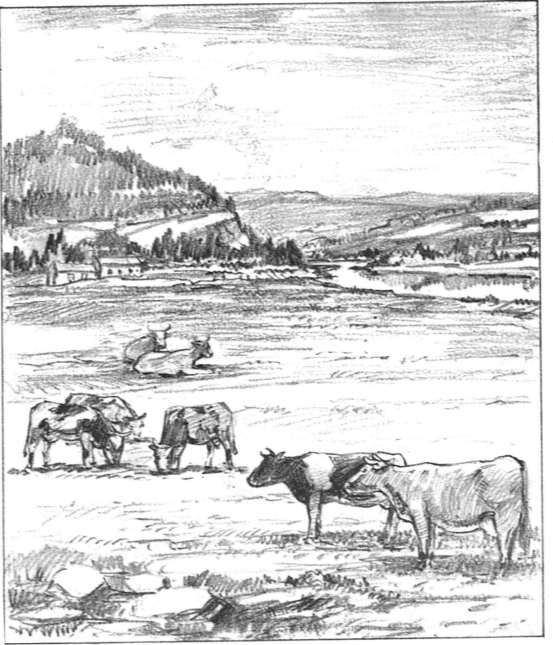

A Pastoral Scene in Vermont

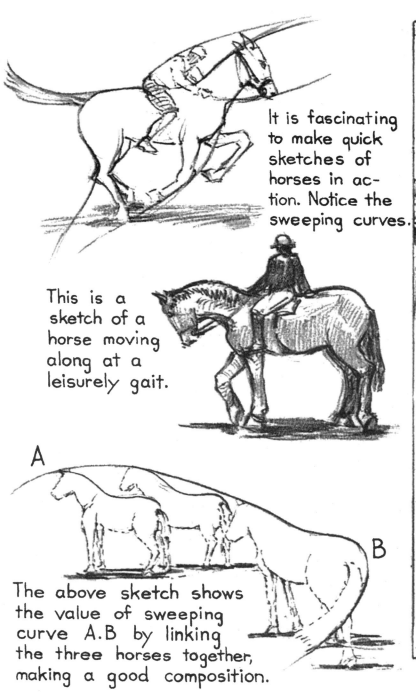

It is fascinating to make quick sketches of horses in action. Notice the sweeping curves.

This is a sketch of a horse moving along at a leisurely gait.

A

B

The above sketch shows the value of sweeping curve A.B by linking the three horses together, making a good composition.

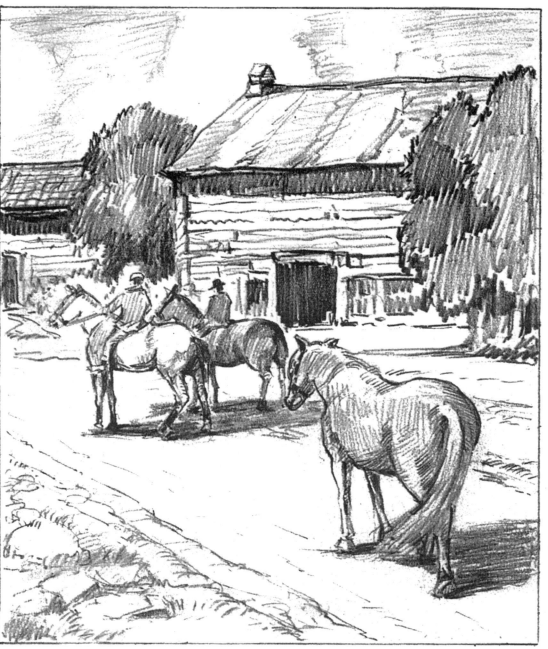

A Homestead in New Mexico

White clothes exposed to sunlight must be drawn with simplicity.

A

B

Trees with thin trunks often display an undulating movement. The buildings behind must be drawn with a delicate touch.

The dark adjoining material silhouettes their shape and brilliancy.

A. Represents the shape of an egg.

B. The same egg formation transposed into a human face.

Sketches of figures seen in street scenes have a pictorial value.

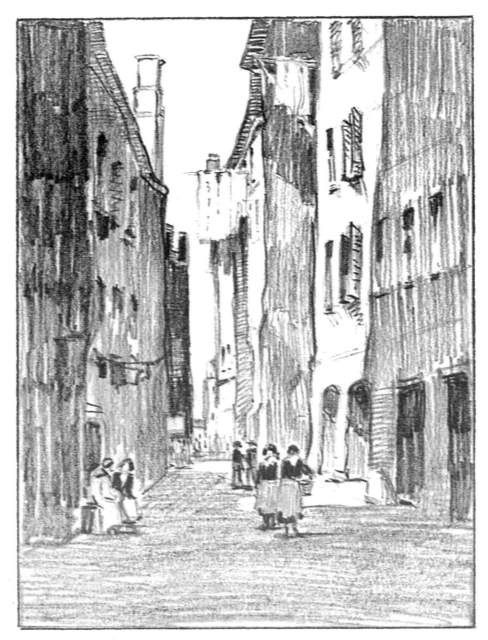

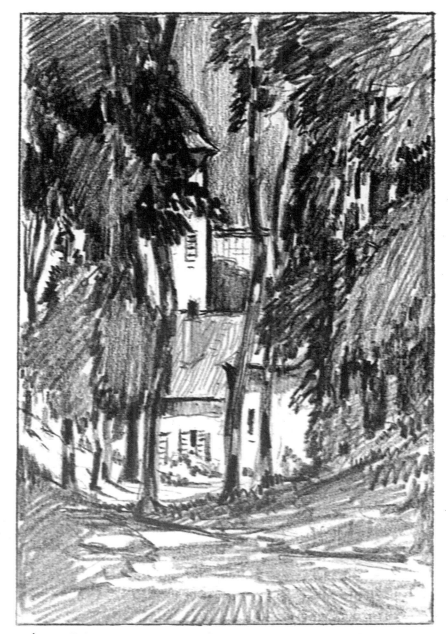

Street Scene, Chioggia, Italy A Church at Besançon, France

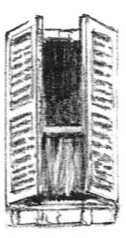

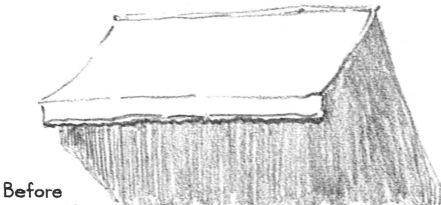

There are many windows in Europe similar to above.

Both shutters open at same angle.

Before suggesting detail under sun blind, shade a flat tone.

Delicate lines to suggest crumbling walls

Final stage — shade with care.

Example of stone work, often seen around old doors.

Studies for Café Cancalais, St. Servan, France

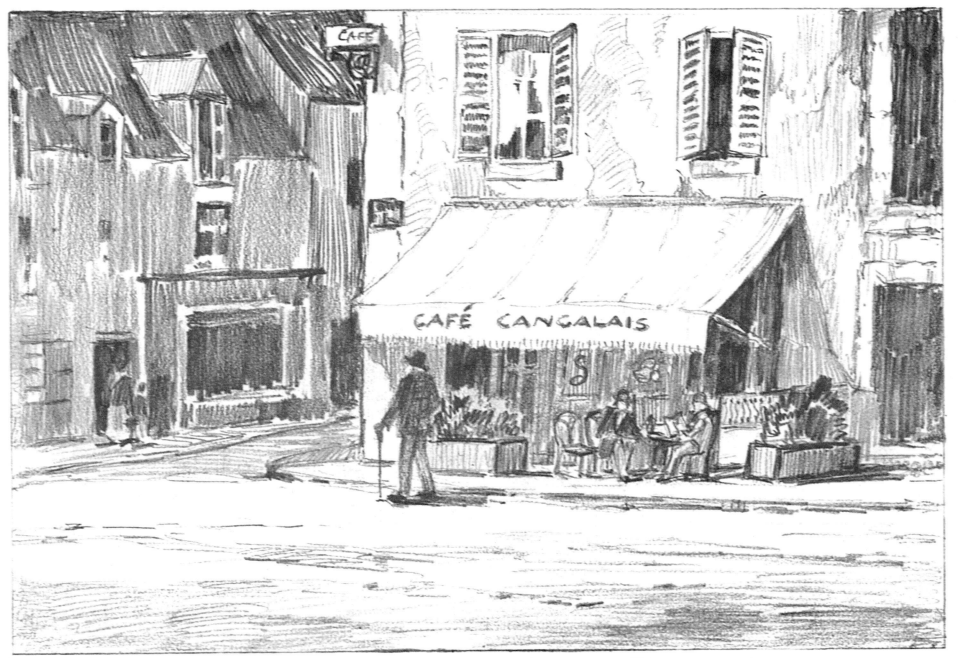

Café Cancalais, St. Servan, France

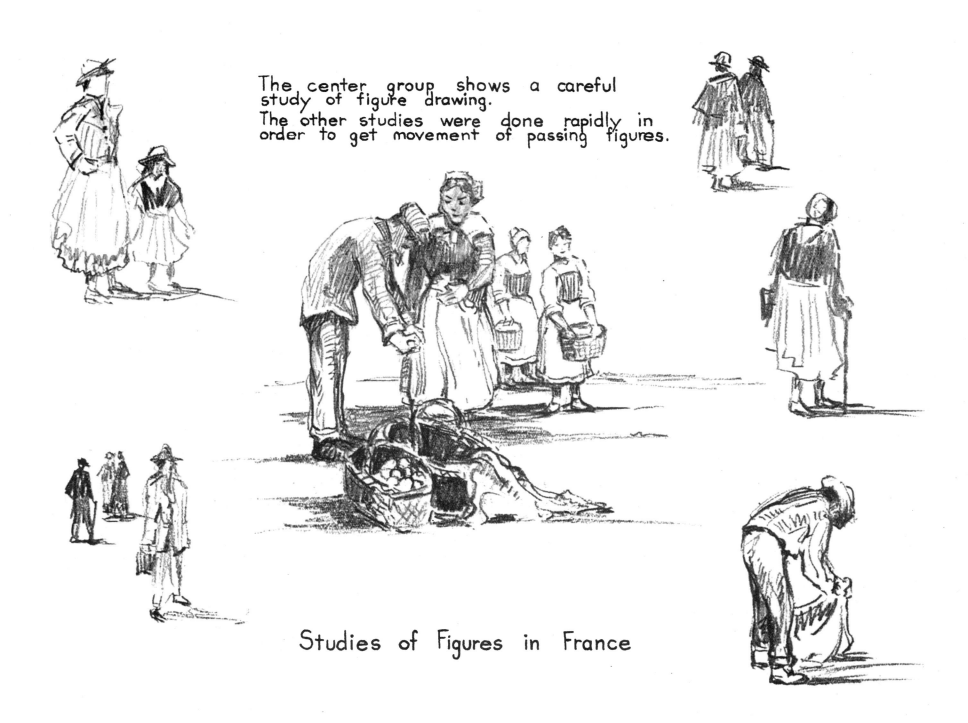

The center group shows a careful
study of figure drawing.
The other studies were done rapidly in
order to get movement of passing figures.

Studies of Figures in France

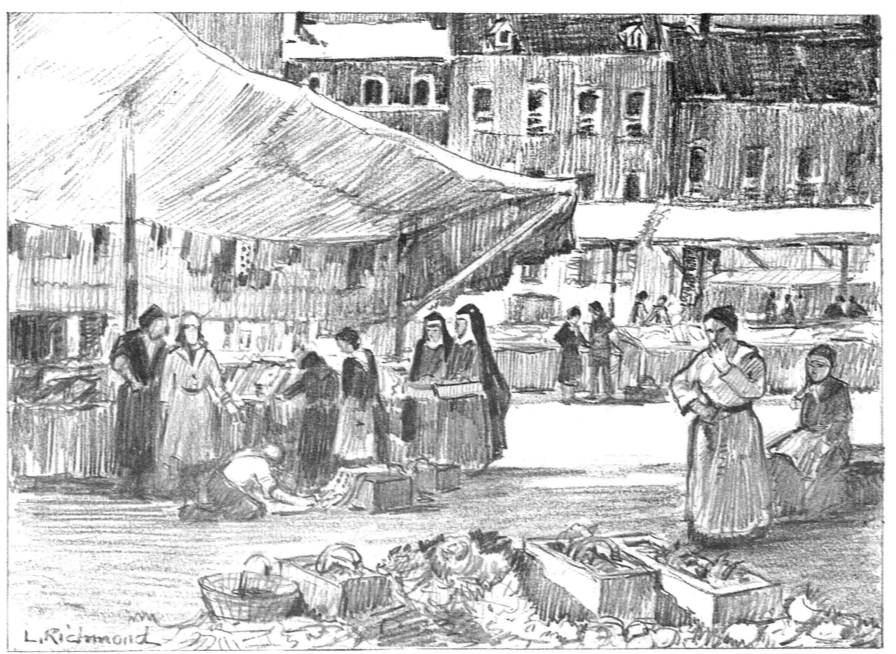

Market Day, Etaples, France

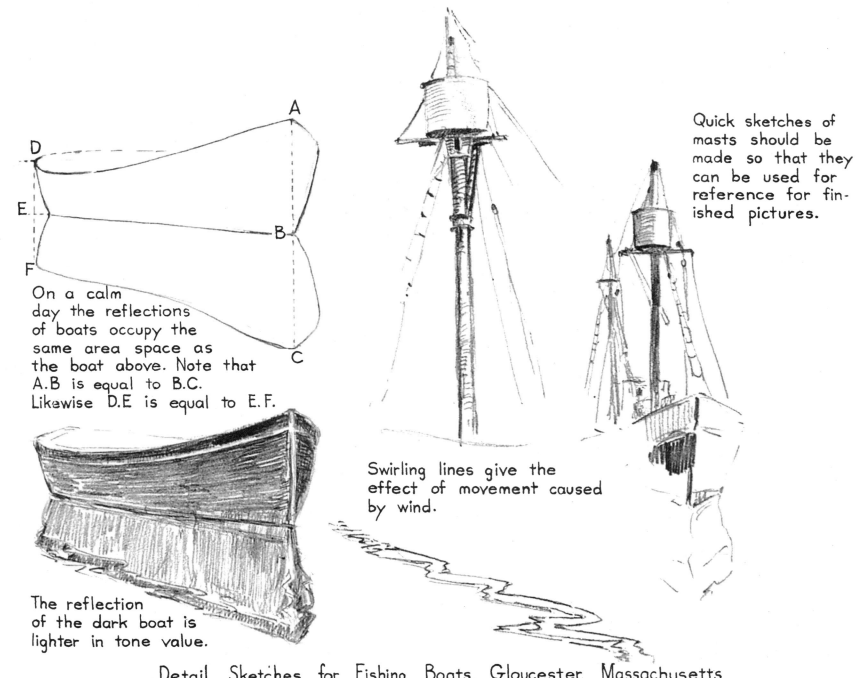

On a calm
day the reflections
of boats occupy the
same area space as
the boat above. Note that
A.B is equal to B.C.
Likewise D.E is equal to E.F.

The reflection
of the dark boat is
lighter in tone value.

Quick sketches of
masts should be
made so that they
can be used for
reference for fin-
ished pictures.

Swirling lines give the
effect of movement caused
by wind.

Detail Sketches for Fishing Boats, Gloucester, Massachusetts

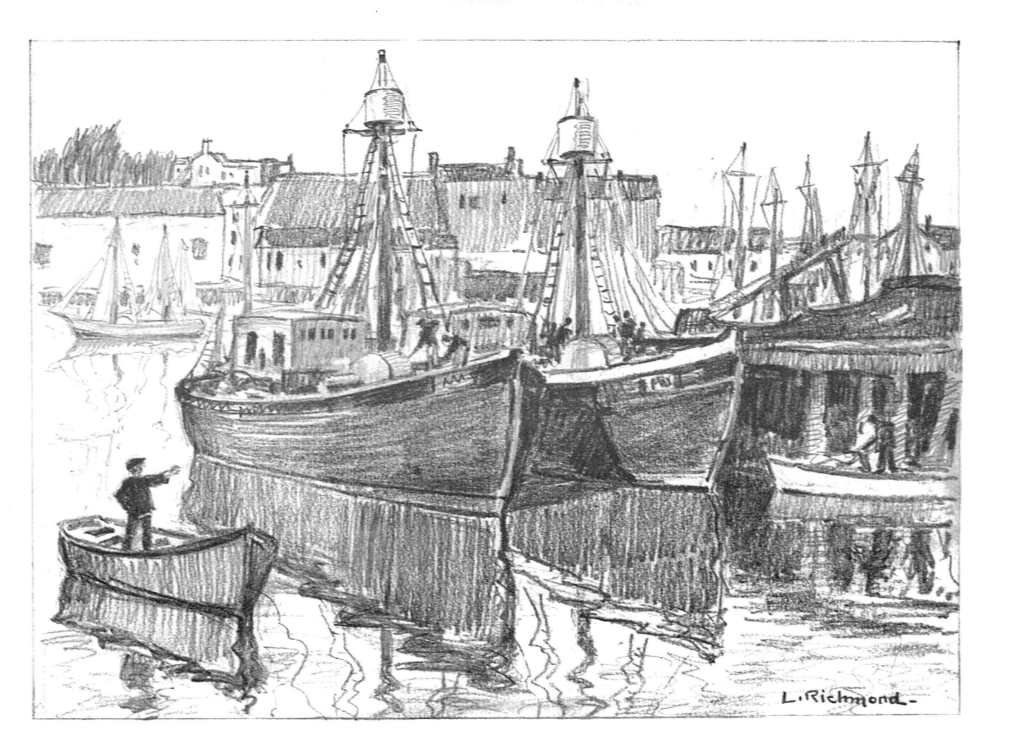

L. Richmond

To get the effect of brilliant sunlight on roofs, leave the paper untouched. The surrounding shadows indicate the shape of buildings. Should it be necessary to suggest detail, it must be drawn with delicacy so as not to disturb the effect of light.

To portray the woodwork of old buildings, allow your pencil to move horizontally with a flowing or undulating line.

Avoid the rigidity of the above horizontal lines. There is a great deal of charm in rendering old buildings with a 4B or 6B pencil.

Always remember that dark objects above the water, such as buildings, are lighter in tone value in their reflections below; whereas light objects show darker reflections.

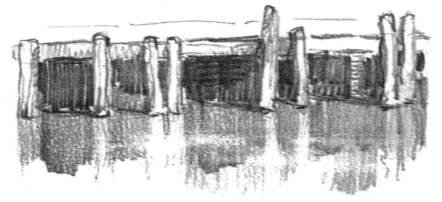

It is fascinating to watch the varying movements on the surface of water caused by a slight wind. This makes a horizontal ripple which breaks some of the reflections from above.

For the reflections of the posts, leave the paper untouched and then shade so as to suggest the correct tonal values.

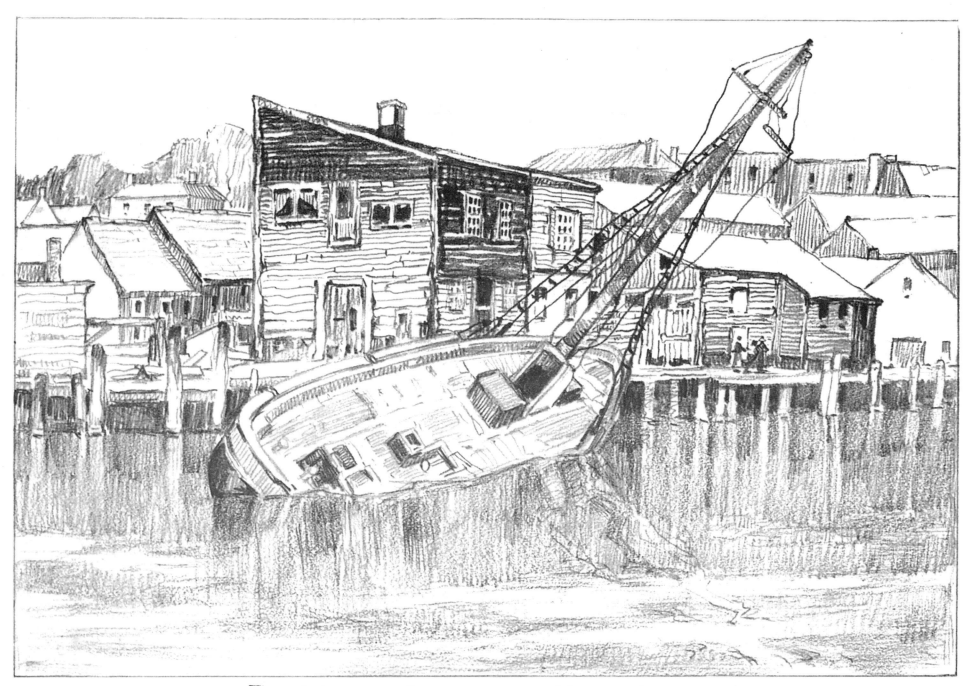

The Wreck, Gloucester, Massachusetts

To shade roofs of build-
ings, see that the pencil
lines follow the sloping
direction of the roof.

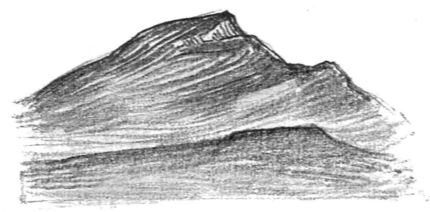

As for the roofs of buildings, pencil lines
are most helpful for indicating the direction
and formation of mountains.

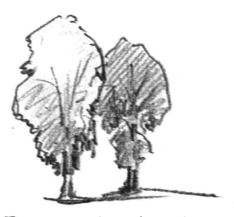

Trees rendered with severe
vertical rigidity are some-
times misplaced in a land-
scape.

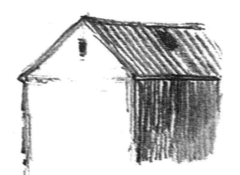

Another example of
roof drawing.

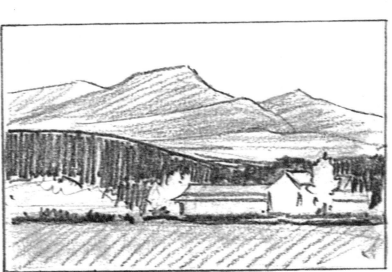

The above demonstrates the basic pattern
of the picture, on the opposite page.

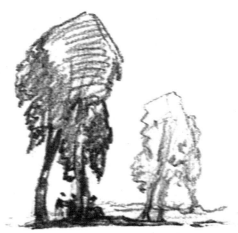

A lyrical feeling appears
when tree trunks are
drawn with an undulating
movement.

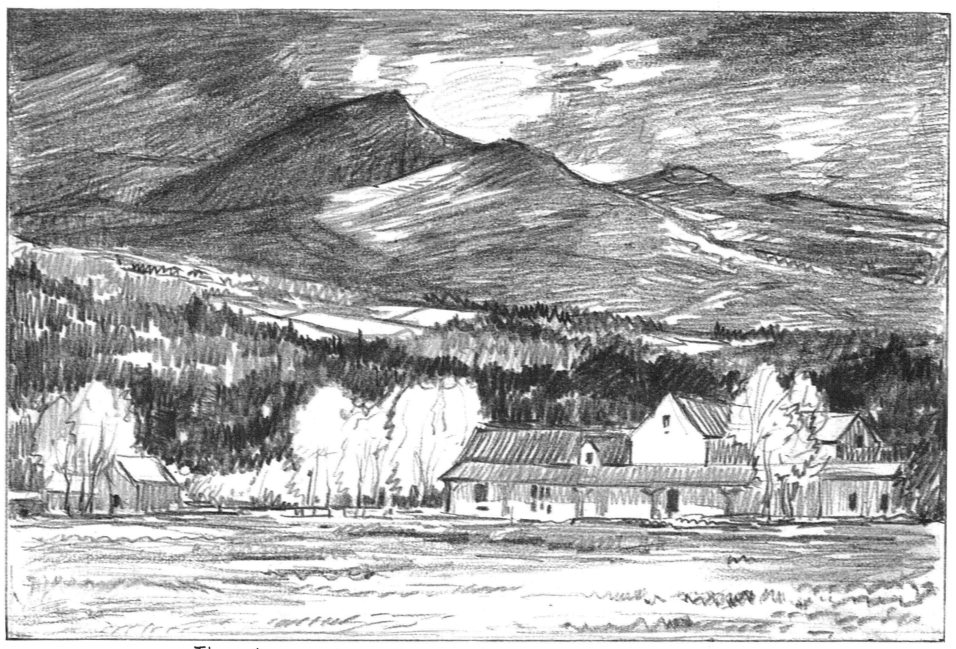

The Approaching Storm, Keene Valley, New York

Receding lines above the level of the eye slope downward. Lines below eye level move upward.

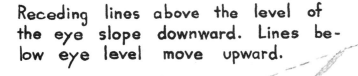

Light-toned buildings have light shadows. Dark-toned buildings have dark shadows.

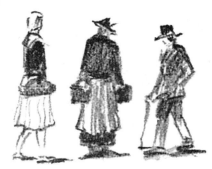

Make many quick sketches of outdoor figures.

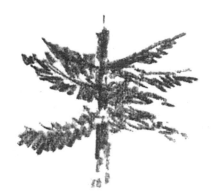

Draw fir trees with decisive shapes.

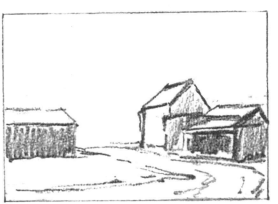

The above is poor composition.

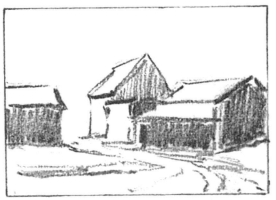

The second example is good space filling. The general proportions are most satisfactory.

Studies for Farm Buildings, Elizabethtown, New York

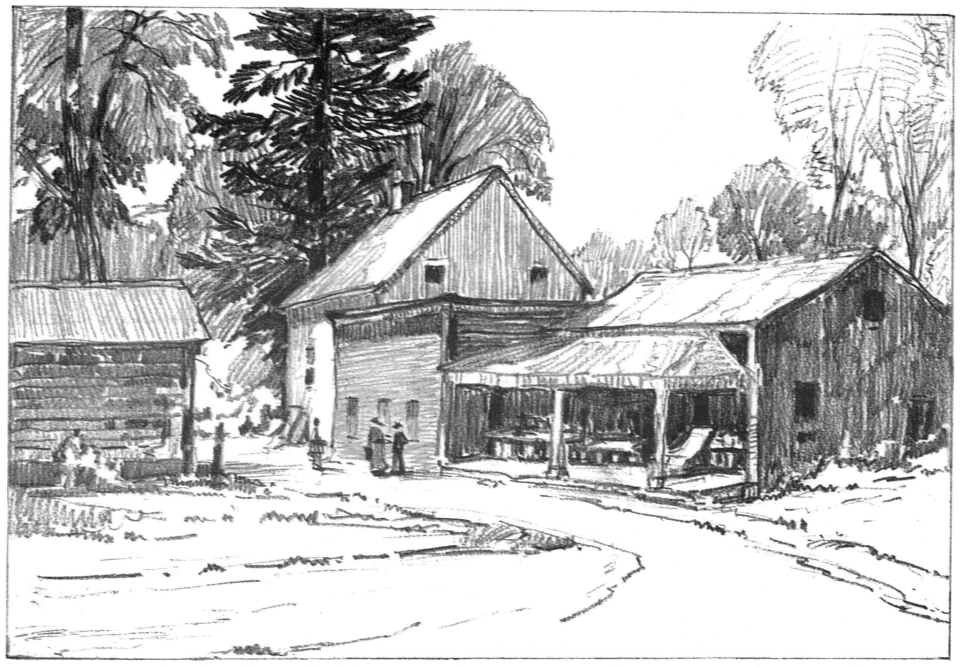

Farm Buildings, Elizabethtown, New York

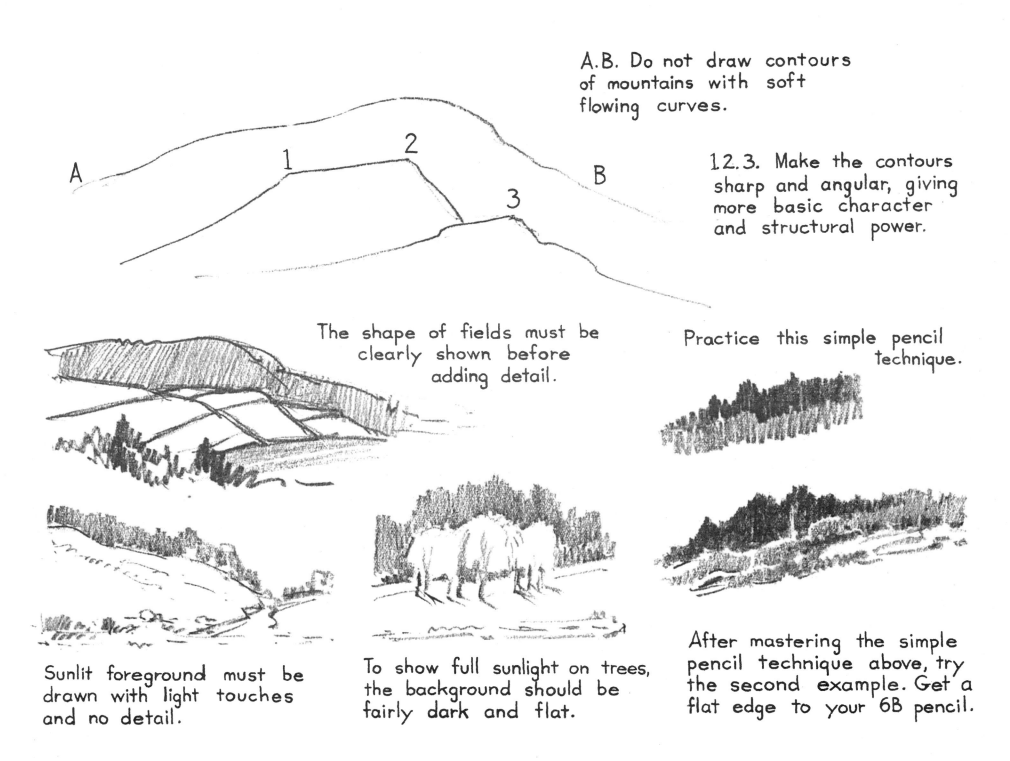

A.B. Do not draw contours of mountains with soft flowing curves.

1.2.3. Make the contours sharp and angular, giving more basic character and structural power.

The shape of fields must be clearly shown before adding detail.

Practice this simple pencil technique.

Sunlit foreground must be drawn with light touches and no detail.

To show full sunlight on trees, the background should be fairly dark and flat.

After mastering the simple pencil technique above, try the second example. Get a flat edge to your 6B pencil.

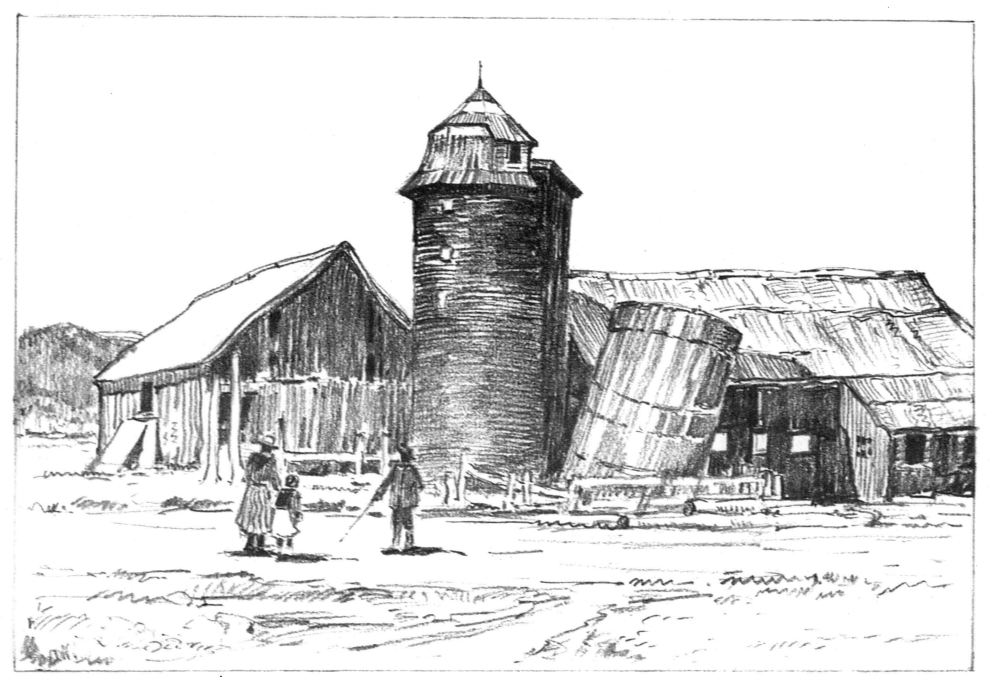

Another View of Barn near Wadhams, New York

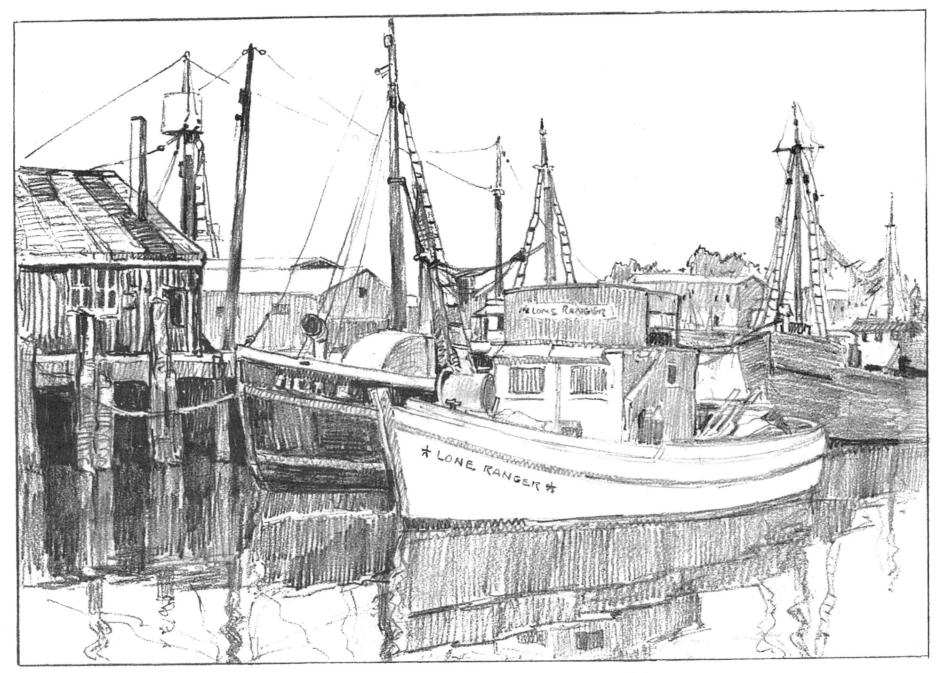

Boats Resting in the Harbor, Gloucester, Massachusetts

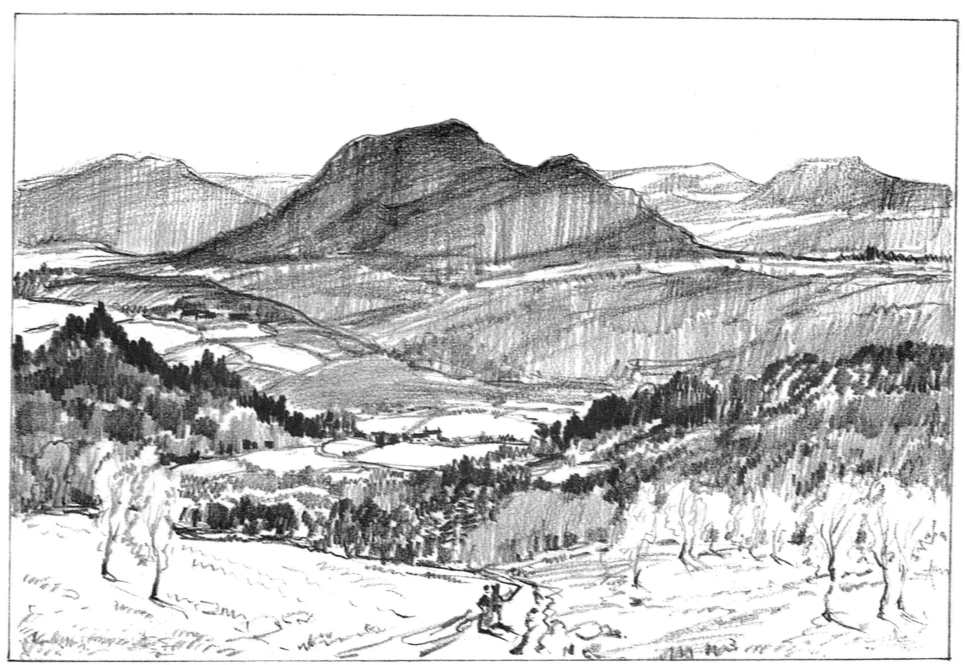

Adirondack Mountains, Wilmington, New York

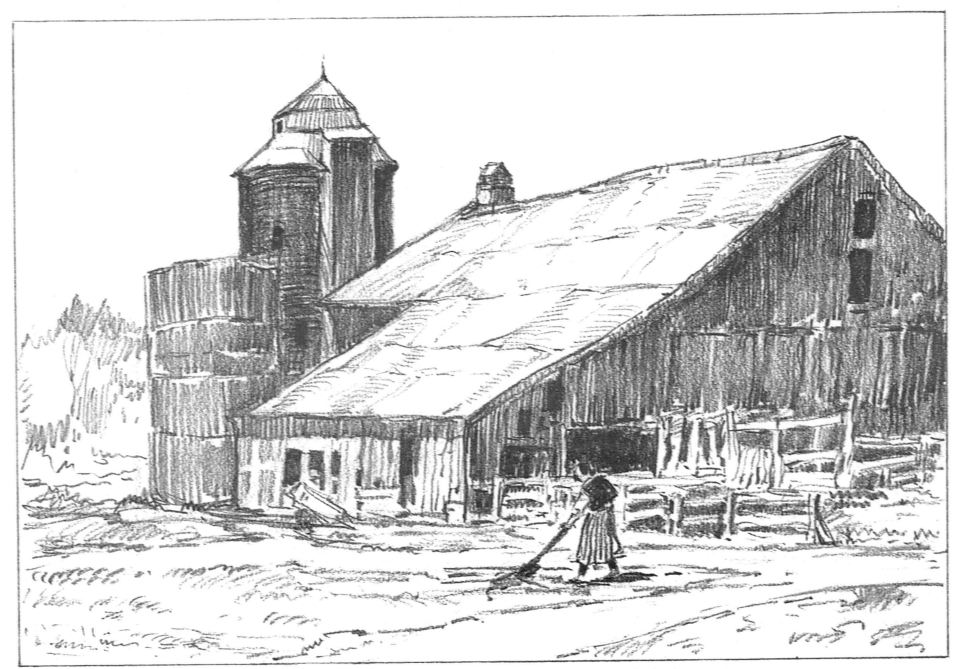

A Barn near Wadhams, New York